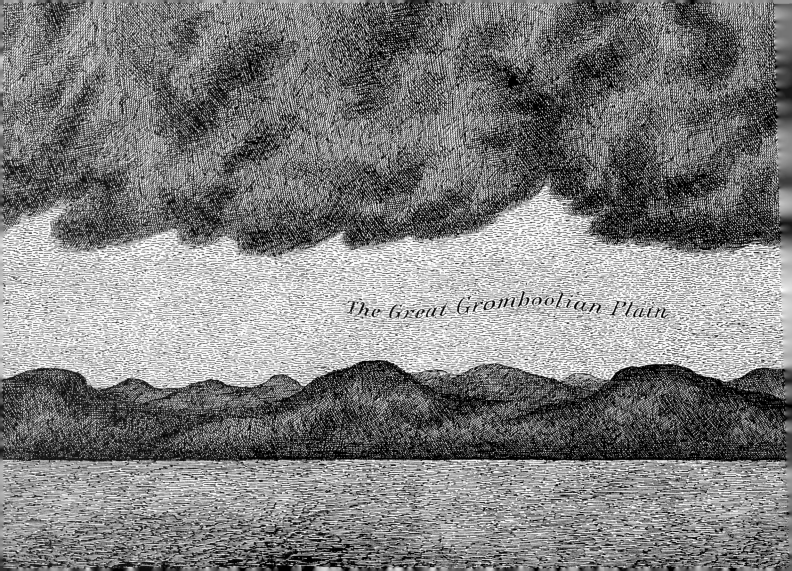

The Great Gromboolian Plain

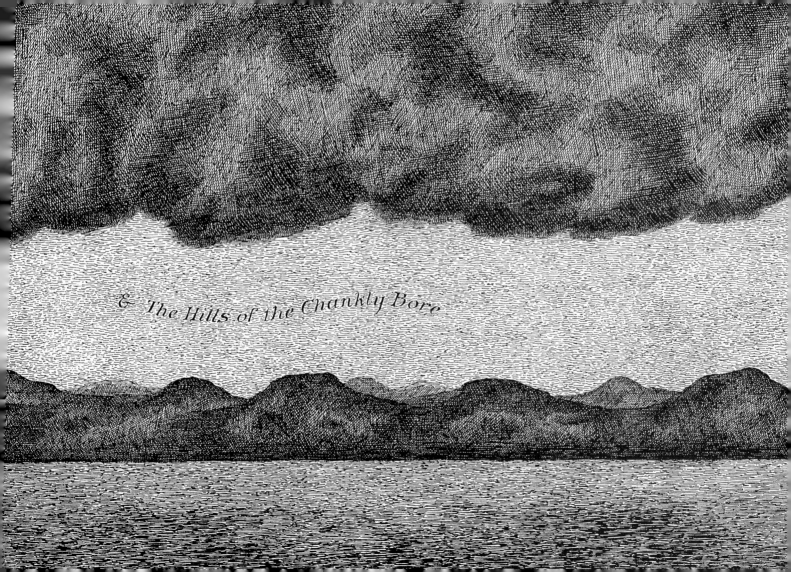

& The Hills of the Chankly Bore

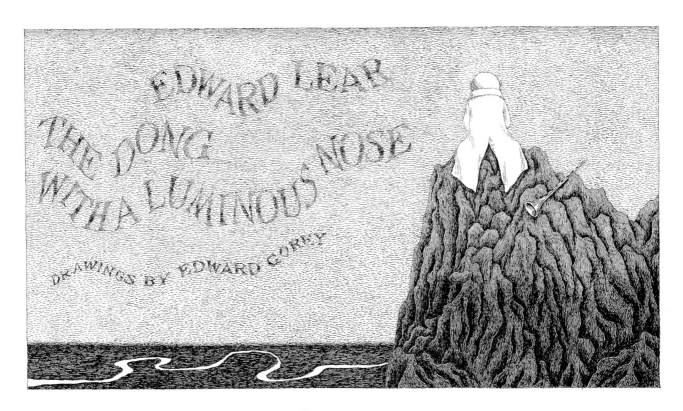

EDWARD LEAR

THE DONG
WITH A LUMINOUS NOSE

DRAWINGS BY EDWARD GOREY

Pomegranate

SAN FRANCISCO

Published by Pomegranate Communications, Inc.
Box 808022, Petaluma CA 94975
800 227 1428 707 782 9000
www.pomegranate.com

Pomegranate Europe Ltd.
Unit 1, Heathcote Business Centre, Hurlbutt Road
Warwick, Warwickshire CV34 6TD, UK
[+44] 0 1926 430111 sales@pomeurope.co.uk

Library of Congress Control Number: 2009936967

ISBN 978-0-7649-5427-6

Pomegranate Catalog No. A183
Designed by Patrice Morris
Printed in China

19 18 17 16 15 14 13 12 11 10 10 9 8 7 6 5 4 3 2 1

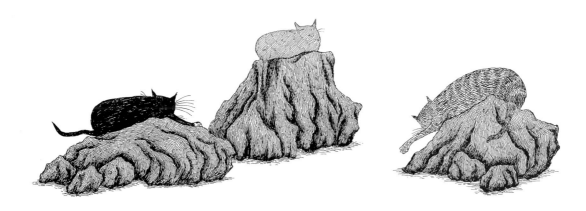

When awful darkness and silence reign
Over the great Gromboolian plain,
 Through the long, long wintry nights ;—
When the angry breakers roar
As they beat on the rocky shore ;—
 When Storm-clouds brood on the towering heights
Of the Hills of the Chankly Bore :—

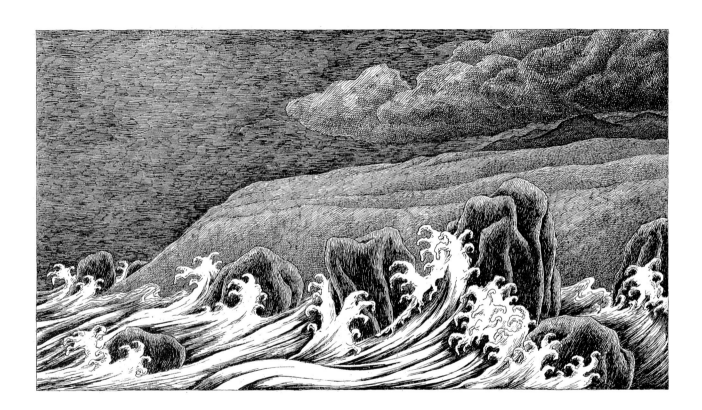

Then, through the vast and gloomy dark,
There moves what seems a fiery spark,
 A lonely spark with silvery rays
 Piercing the coal-black night,—
 A Meteor strange and bright:—
Hither and thither the vision strays,
 A single lurid light.

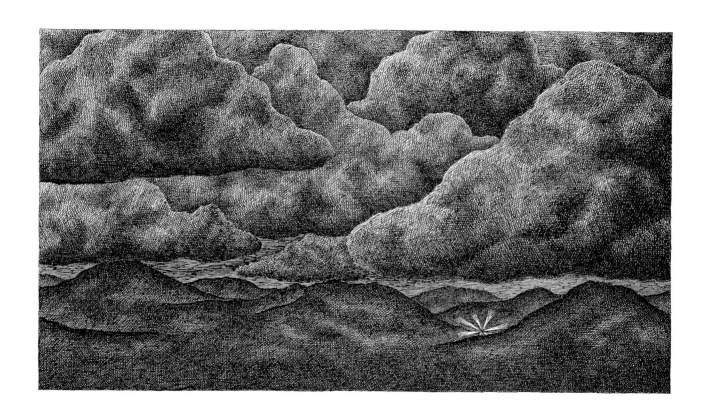

Slowly it wanders,—pauses,—creeps,—
Anon it sparkles,—flashes and leaps;
And ever as onward it gleaming goes
A light on the Bong-tree stems it throws.

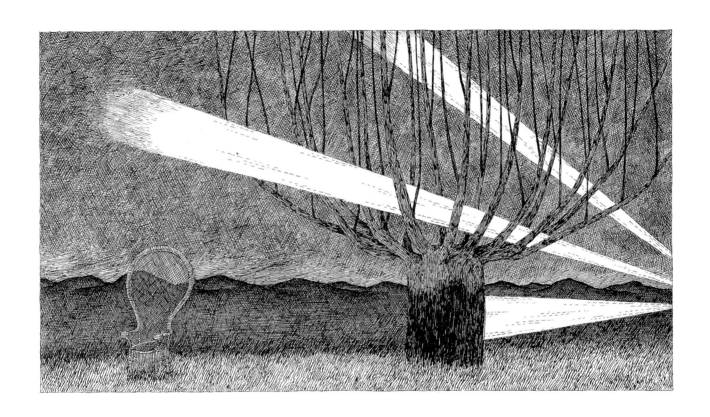

And those who watch at that midnight hour
From Hall or Terrace, or lofty Tower,
Cry, as the wild light passes along,—
 'The Dong!—the Dong!
 'The wandering Dong through the forest goes!
 'The Dong! the Dong!
 'The Dong with a luminous Nose!'

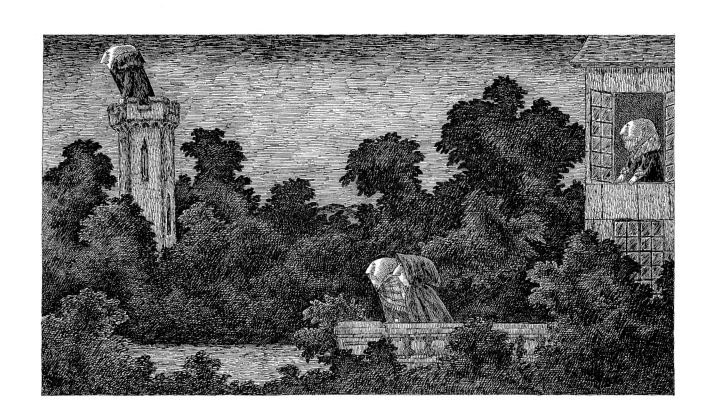

Long years ago

The Dong was happy and gay,

Till he fell in love with a Jumbly Girl

Who came to those shores one day,

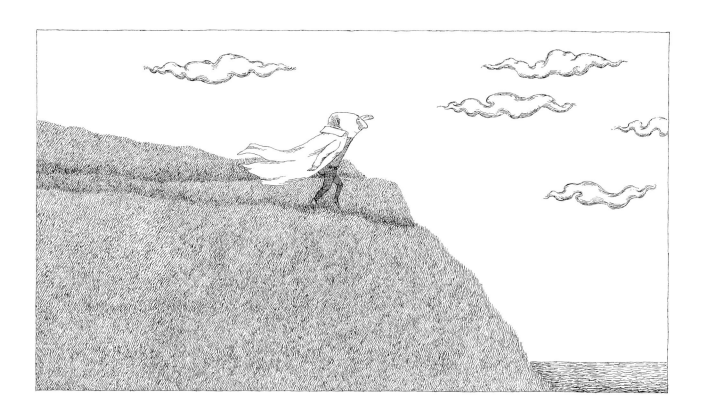

For the Jumblies came in a sieve, they did,—
Landing at eve near the Zemmery Fidd
Where the Oblong Oysters grow,
And the rocks are smooth and gray.
And all the woods and the valleys rang
With the Chorus they daily and nightly sang,—

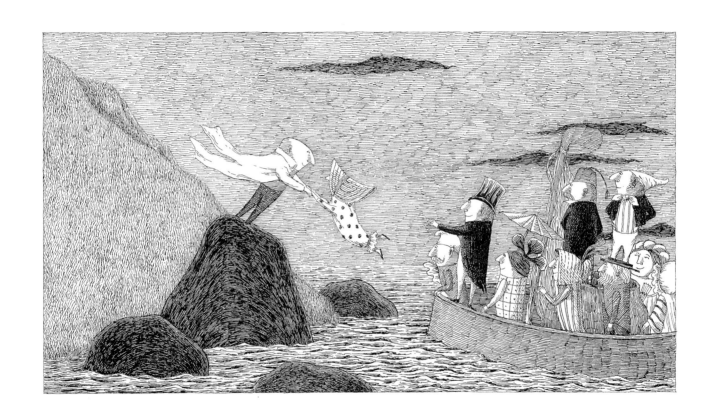

'Far and few, far and few,
Are the lands where the Jumblies live ;
Their heads are green, and their hands are blue,
And they went to sea in a sieve.'

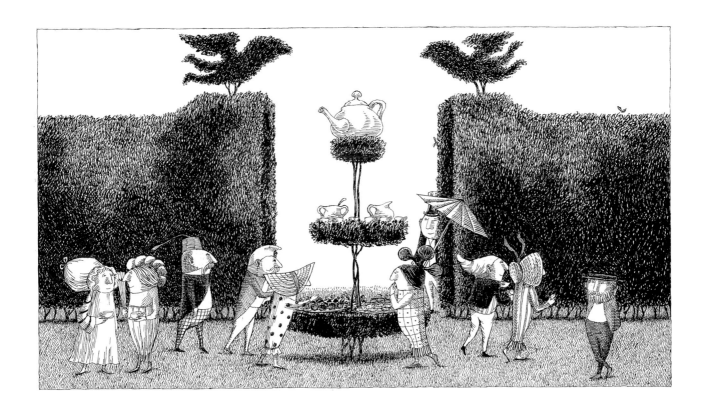

Happily, happily passed those days!
　　While the cheerful Jumblies staid;
　　They danced in circlets all night long,
　　To the plaintive pipe of the lively Dong,
　　In moonlight, shine, or shade.
For day and night he was always there
By the side of the Jumbly Girl so fair,
With her sky-blue hands, and her sea-green hair.

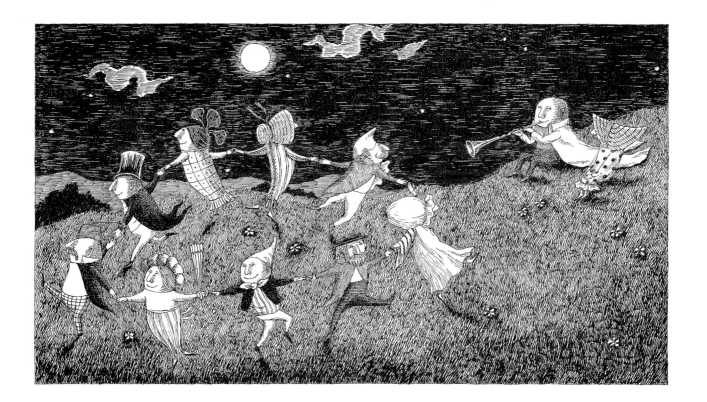

Till the morning came of that hateful day
When the Jumblies sailed in their sieve away,
And the Dong was left on the cruel shore
Gazing—gazing for evermore,—
Ever keeping his weary eyes on
That pea-green sail on the far horizon,—
Singing the Jumbly Chorus still
As he sate all day on the grassy hill,—

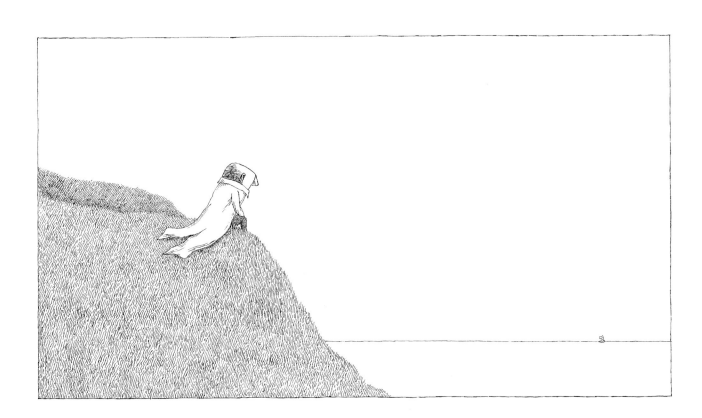

'Far and few, far and few,
Are the lands where the Jumblies live;
Their heads are green, and their hands are blue,
And they went to sea in a sieve.'

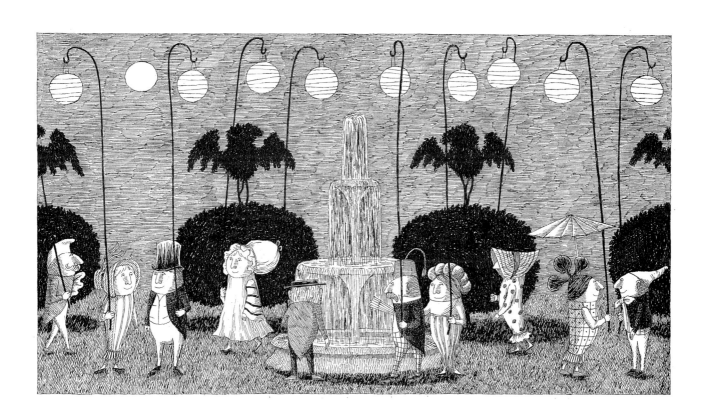

But when the sun was low in the West,
The Dong arose and said;—
—'What little sense I once possessed
Has quite gone out of my head!'—

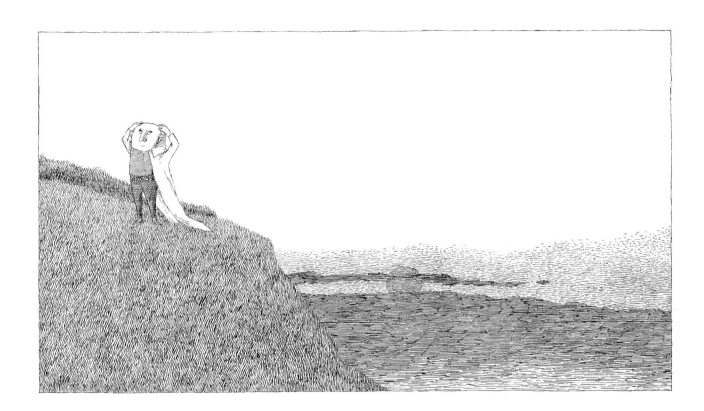

And since that day he wanders still
By lake and forest, marsh and hill,
Singing—'O somewhere, in valley or plain
'Might I find my Jumbly Girl again!
'For ever I'll seek by lake and shore
'Till I find my Jumbly Girl once more!'

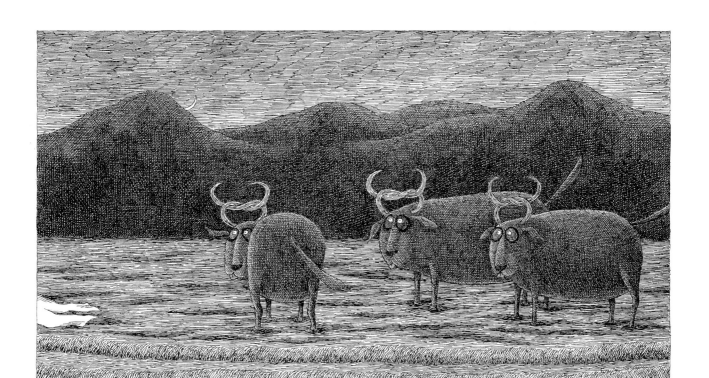

Playing a pipe with silvery squeaks,
Since then his Jumbly Girl he seeks,
And because by night he could not see,
He gathered the bark of the Twangum Tree
 On the flowery plain that grows.

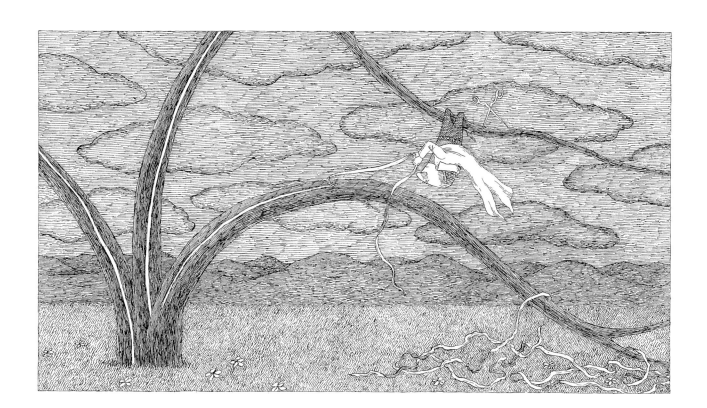

And he wove him a wondrous Nose,—
A Nose as strange as a Nose could be!
Of vast proportions and painted red,
And tied with cords to the back of his head.

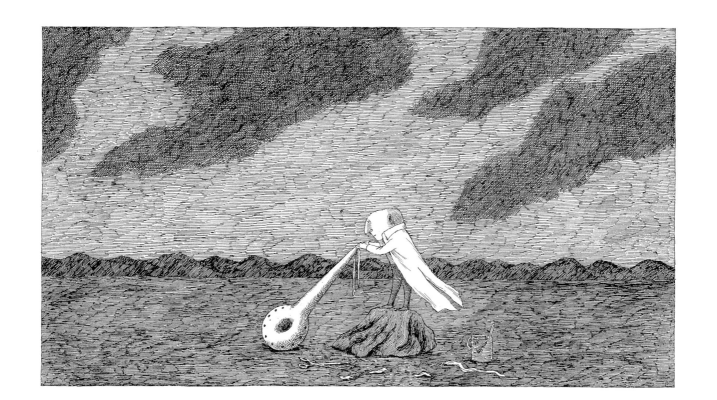

—In a hollow rounded space it ended
With a luminous Lamp within suspended,
 All fenced about
 With a bandage stout
 To prevent the wind from blowing it out;—
And with holes all round to send the light,
In gleaming rays on the dismal night.

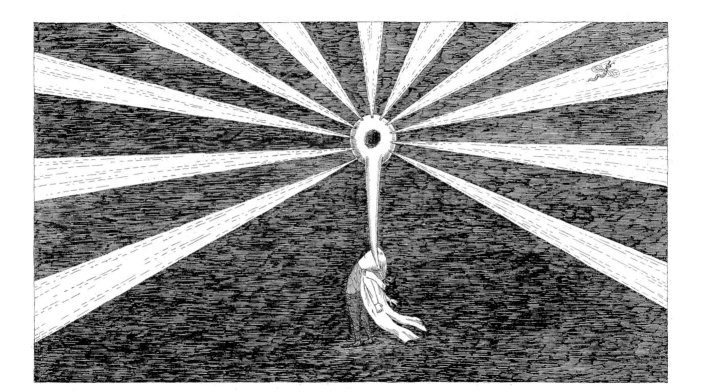

And now each night, and all night long,
Over those plains still roams the Dong;
And above the wail of the Chimp and Snipe
You may hear the squeak of his plaintive pipe
While ever he seeks, but seeks in vain
To meet with his Jumbly Girl again;
Lonely and wild—all night he goes,—
The Dong with a luminous Nose!

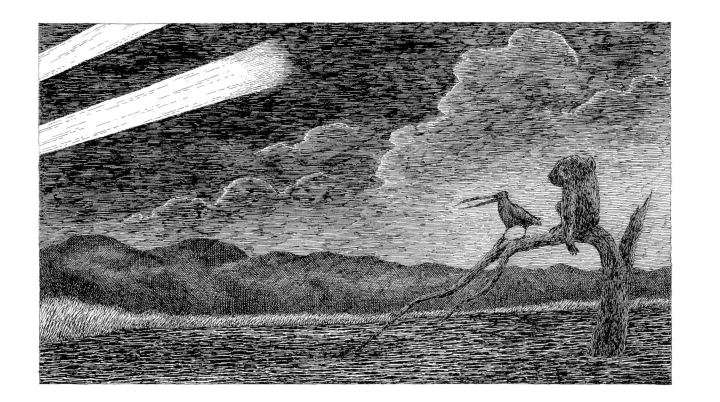

And all who watch at the midnight hour,
From Hall or Terrace, or lofty Tower,
Cry, as they trace the Meteor bright,
Moving along through the dreary night,—

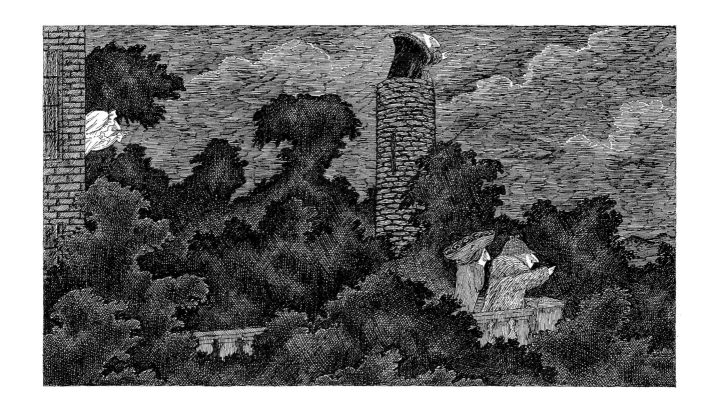

'This is the hour when forth he goes,
'The Dong with a luminous Nose!
'Yonder—over the plain he goes;
 'He goes!
 'He goes;
'The Dong with a luminous Nose!'

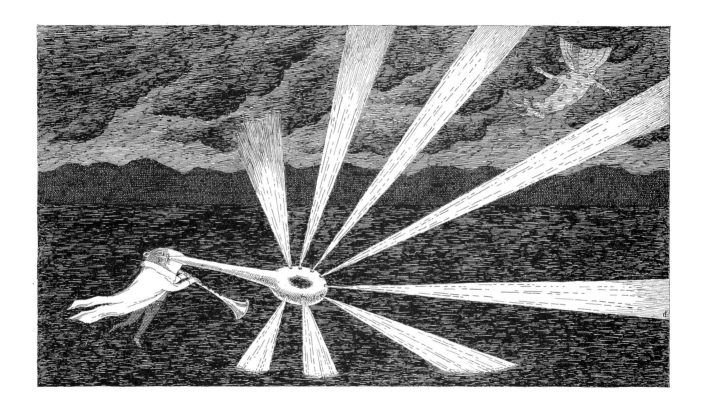

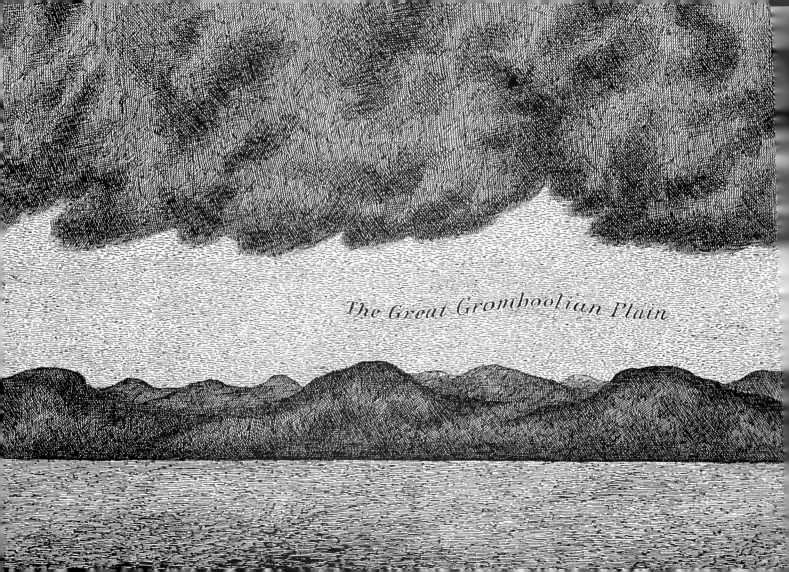

The Great Gromboolian Plain

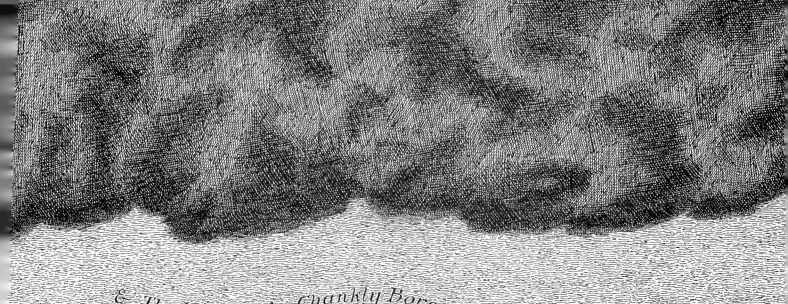
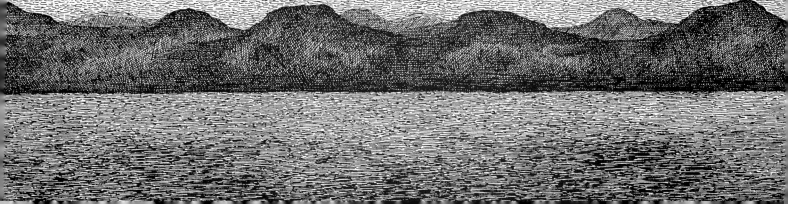

& The Hills of the Chankly Bore

Edward Gorey books from Pomegranate, in print or coming soon:

The Awdrey-Gore Legacy

The Black Doll: A Silent Screenplay

The Blue Aspic

Category

The Eclectic Abecedarium

Edward Gorey: Classic Children's Stories

Edward Gorey: The New Poster Book

Elegant Enigmas: The Art of Edward Gorey

Elephant House; or, The Home of Edward Gorey, by Kevin McDermott

The Gilded Bat

The Hapless Child

The Jumblies, text by Edward Lear

The Remembered Visit

The Sopping Thursday

The Twelve Terrors of Christmas, text by John Updike

The Utter Zoo

The Wuggly Ump